Color By Number Coloring Book For Relaxation

This Adult Color By Number Book belongs to:

Copyright © 2019 Adult Coloring Books

1. Red
2. Green
3. Blue
4. Pink
5. Purple
6. Light Blue
7. Light Green
8. Orange
9. Dark Red
10. Brown
11. Black
12. Dark Green
13. Gold
14. Violet
15. Yellow

1. Red
2. Green
3. Blue
4. Pink
5. Purple
6. Light Blue
7. Light Green
8. Orange
9. Dark Red
10. Brown
11. Black
12. Dark Green
13. Gold
14. Violet
15. Yellow

1. Red
2. Green
3. Blue
4. Pink
5. Purple
6. Light Blue
7. Light Green
8. Orange
9. Dark Red
10. Brown
11. Black
12. Dark Green
13. Gold
14. Violet
15. Yellow

1. Red
2. Green
3. Blue
4. Pink
5. Purple
6. Light Blue
7. Light Green
8. Orange
9. Dark Red
10. Brown
11. Black
12. Dark Green
13. Gold
14. Violet
15. Yellow

1. Red
2. Green
3. Blue
4. Pink
5. Purple
6. Light Blue
7. Light Green
8. Orange
9. Dark Red
10. Brown
11. Black
12. Dark Green
13. Gold
14. Violet
15. Yellow

1. Blue
2. Dark Blue
3. Black
4. Yellow
5. Green
6. Brown
7. Dark Blue
8. Gold
9. Dark Green
10. Purple

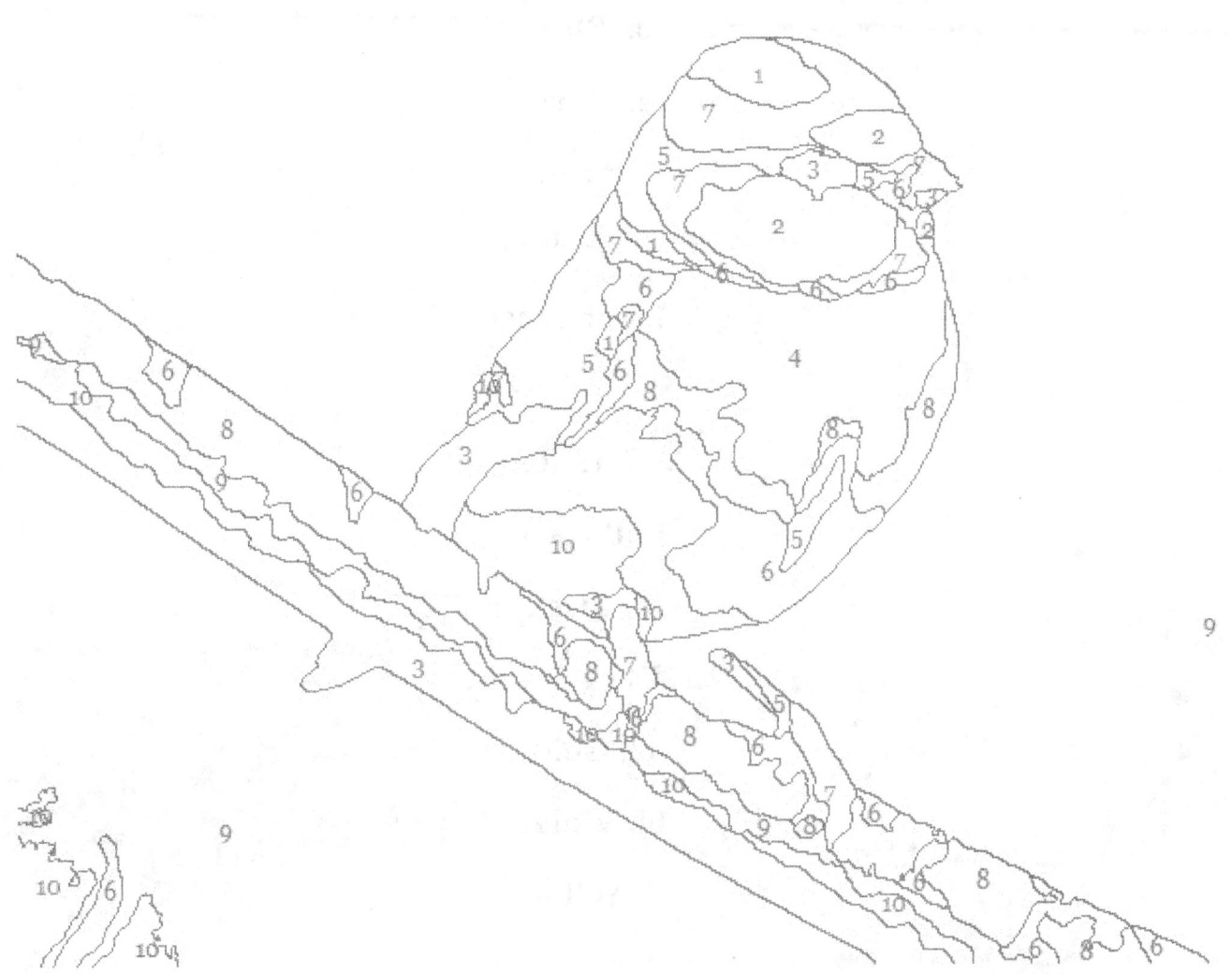

1. Red
2. Green
3. Blue
4. Pink
5. Purple
6. Light Blue
7. Light Green
8. Orange
9. Dark Red
10. Brown
11. Black
12. Dark Green
13. Gold
14. Violet
15. Yellow

1. Red
2. Green
3. Blue
4. Pink
5. Purple
6. Light Blue
7. Light Green
8. Orange
9. Dark Red
10. Brown
11. Black
12. Dark Green
13. Gold
14. Violet
15. Yellow

1. Red
2. Green
3. Blue
4. Pink
5. Purple
6. Light Blue
7. Light Green
8. Orange
9. Dark Red
10. Brown
11. Black
12. Dark Green
13. Gold
14. Violet
15. Yellow

1. Red
2. Green
3. Blue
4. Pink
5. Purple
6. Light Blue
7. Light Green
8. Orange
9. Dark Red
10. Brown
11. Black
12. Dark Green
13. Gold
14. Violet
15. Yellow

1. Red
2. Green
3. Blue
4. Pink
5. Purple
6. Light Blue
7. Light Green
8. Orange
9. Dark Red
10. Brown
11. Black
12. Dark Green
13. Gold
14. Violet
15. Yellow

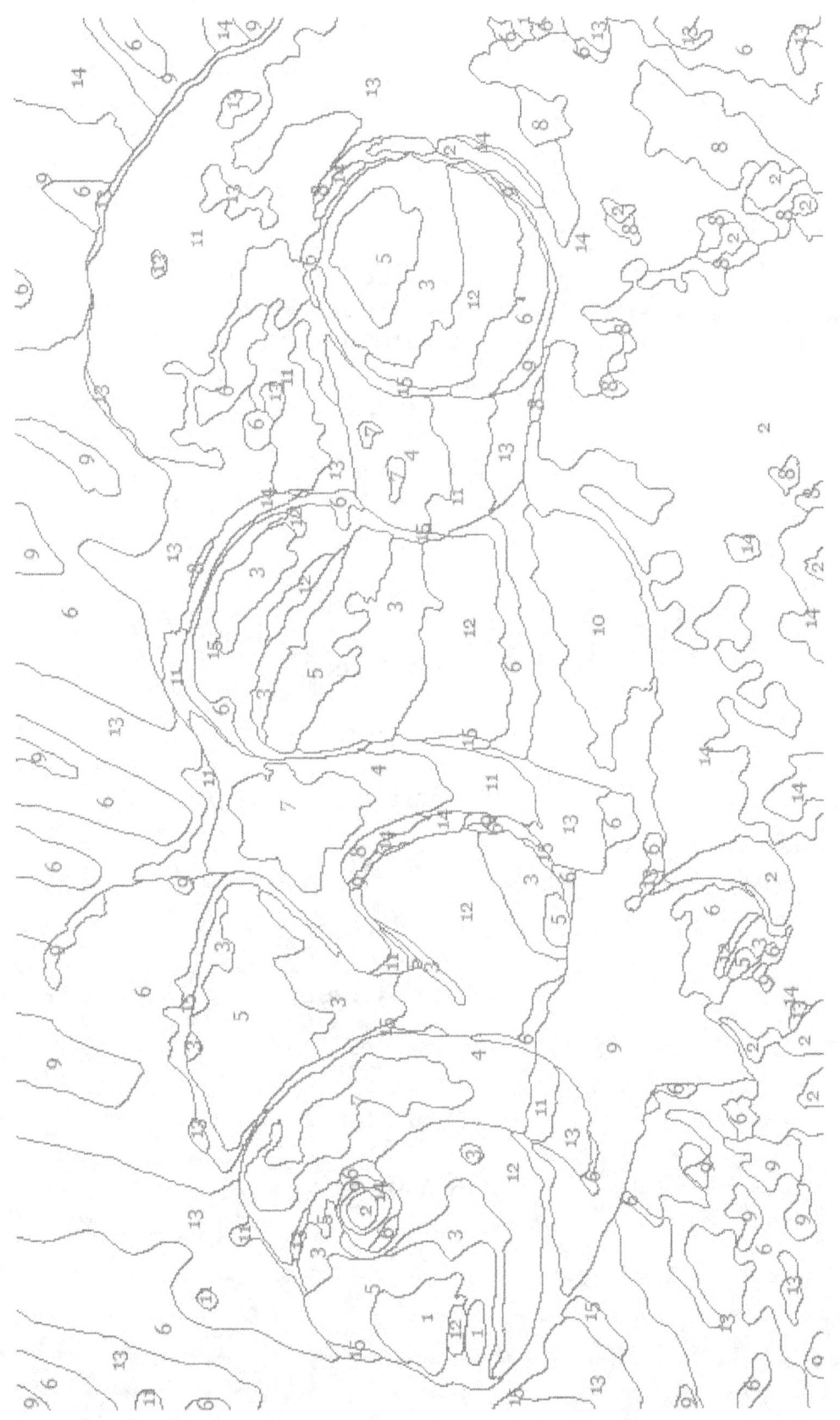

1. Red
2. Green
3. Blue
4. Pink
5. Purple
6. Light Blue
7. Light Green
8. Orange
9. Dark Red
10. Brown
11. Black
12. Dark Green
13. Gold
14. Violet
15. Yellow

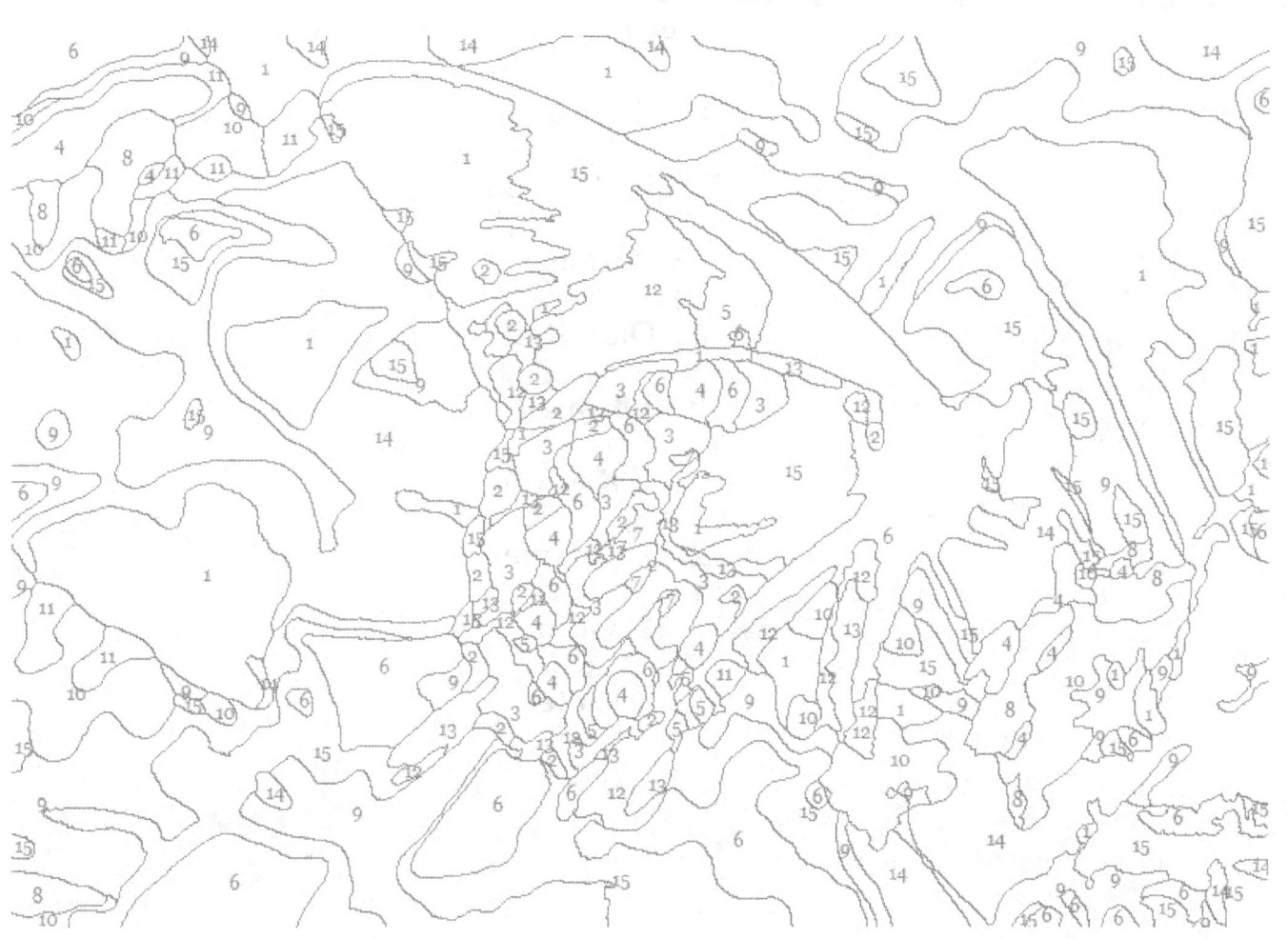

1. Red
2. Green
3. Blue
4. Pink
5. Purple
6. Light Blue
7. Light Green
8. Orange
9. Dark Red
10. Brown
11. Black
12. Dark Green
13. Gold
14. Violet
15. Yellow

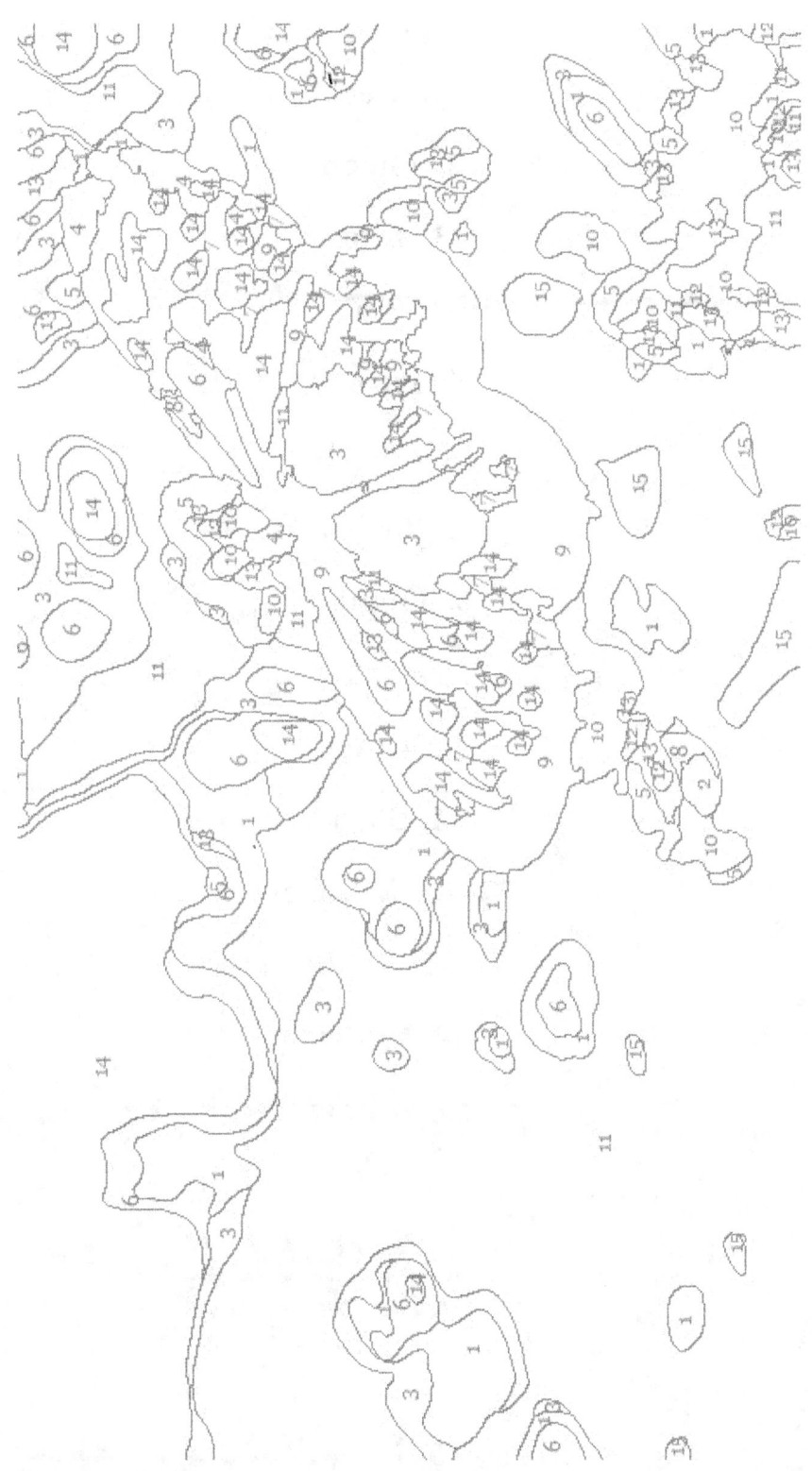

1. Red
2. Green
3. Blue
4. Pink
5. Purple
6. Light Blue
7. Light Green
8. Orange
9. Dark Red
10. Brown
11. Black
12. Dark Green
13. Gold
14. Violet
15. Yellow

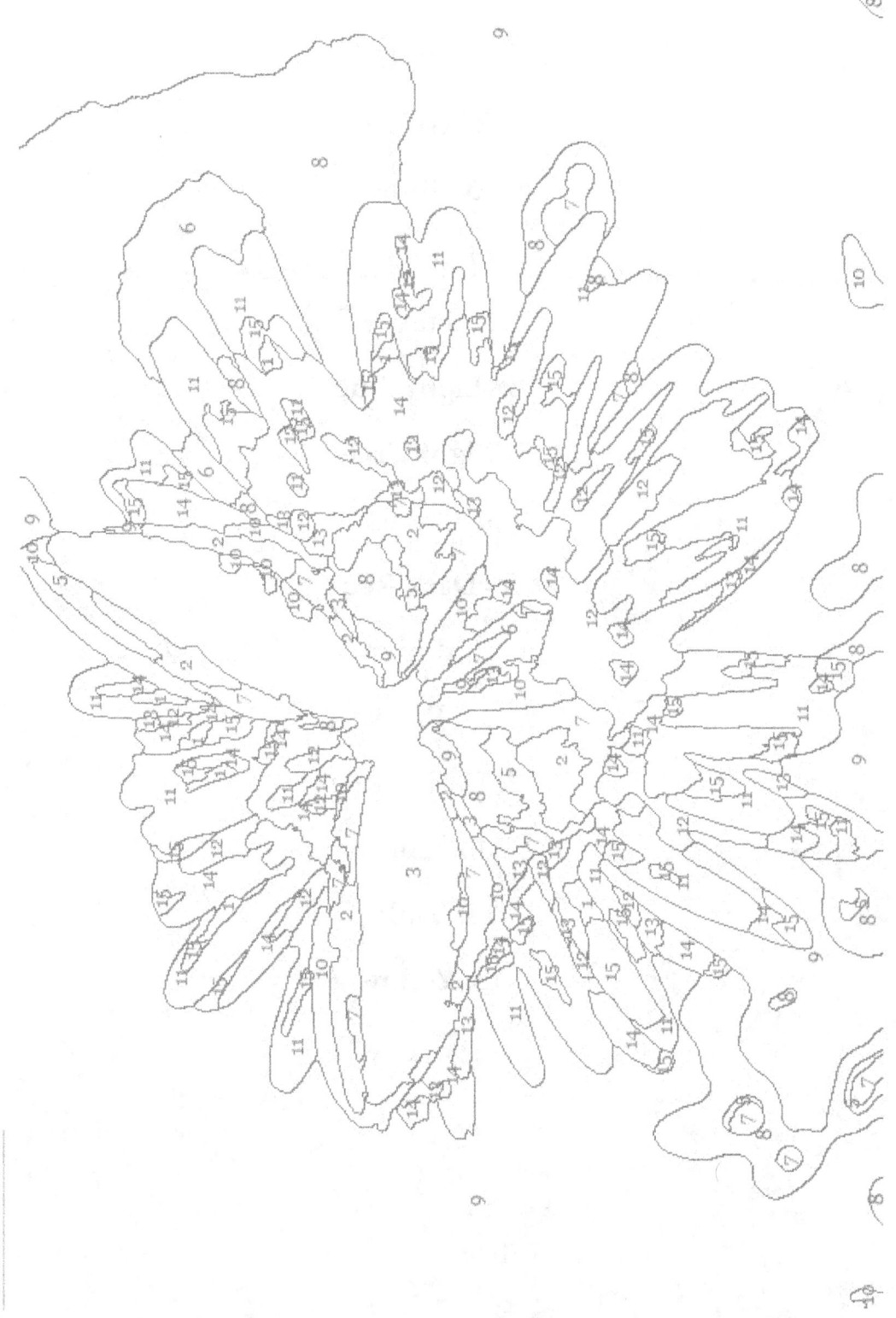

1. Red
2. Green
3. Blue
4. Pink
5. Purple
6. Light Blue
7. Light Green
8. Orange
9. Dark Red
10. Brown
11. Black
12. Dark Green
13. Gold
14. Violet
15. Yellow

1. Red
2. Green
3. Blue
4. Pink
5. Purple
6. Light Blue
7. Light Green
8. Orange
9. Dark Red
10. Brown
11. Black
12. Dark Green
13. Gold
14. Violet
15. Yellow

1. Red
2. Green
3. Blue
4. Pink
5. Purple
6. Light Blue
7. Light Green
8. Orange
9. Dark Red
10. Brown
11. Black
12. Dark Green
13. Gold
14. Violet
15. Yellow

1. Red
2. Green
3. Blue
4. Pink
5. Purple
6. Light Blue
7. Light Green
8. Orange
9. Dark Red
10. Brown
11. Black
12. Dark Green
13. Gold
14. Violet
15. Yellow

1. Red
2. Green
3. Blue
4. Pink
5. Purple
6. Light Blue
7. Light Green
8. Orange
9. Dark Red
10. Brown
11. Black
12. Dark Green
13. Gold
14. Violet
15. Yellow

1. Red
2. Green
3. Blue
4. Pink
5. Purple
6. Light Blue
7. Light Green
8. Orange
9. Dark Red
10. Brown
11. Black
12. Dark Green
13. Gold
14. Violet
15. Yellow

1. Red
2. Green
3. Blue
4. Pink
5. Purple
6. Light Blue
7. Light Green
8. Orange
9. Dark Red
10. Brown
11. Black
12. Dark Green
13. Gold
14. Violet
15. Yellow

1. Red
2. Green
3. Blue
4. Pink
5. Purple
6. Light Blue
7. Light Green
8. Orange
9. Dark Red
10. Brown
11. Black
12. Dark Green
13. Gold
14. Violet
15. Yellow

1. Red
2. Green
3. Blue
4. Pink
5. Purple
6. Light Blue
7. Light Green
8. Orange
9. Dark Red
10. Brown
11. Black
12. Dark Green
13. Gold
14. Violet
15. Yellow

1. Red
2. Green
3. Blue
4. Pink
5. Purple
6. Light Blue
7. Light Green
8. Orange
9. Dark Red
10. Brown
11. Black
12. Dark Green
13. Gold
14. Violet
15. Yellow

1. Red
2. Green
3. Blue
4. Pink
5. Purple
6. Light Blue
7. Light Green
8. Orange
9. Dark Red
10. Brown
11. Black
12. Dark Green
13. Gold
14. Violet
15. Yellow

1. Red
2. Green
3. Blue
4. Pink
5. Purple
6. Light Blue
7. Light Green
8. Orange
9. Dark Red
10. Brown
11. Black
12. Dark Green
13. Gold
14. Violet
15. Yellow

1. Red
2. Green
3. Blue
4. Pink
5. Purple
6. Light Blue
7. Light Green
8. Orange
9. Dark Red
10. Brown
11. Black
12. Dark Green
13. Gold
14. Violet
15. Yellow

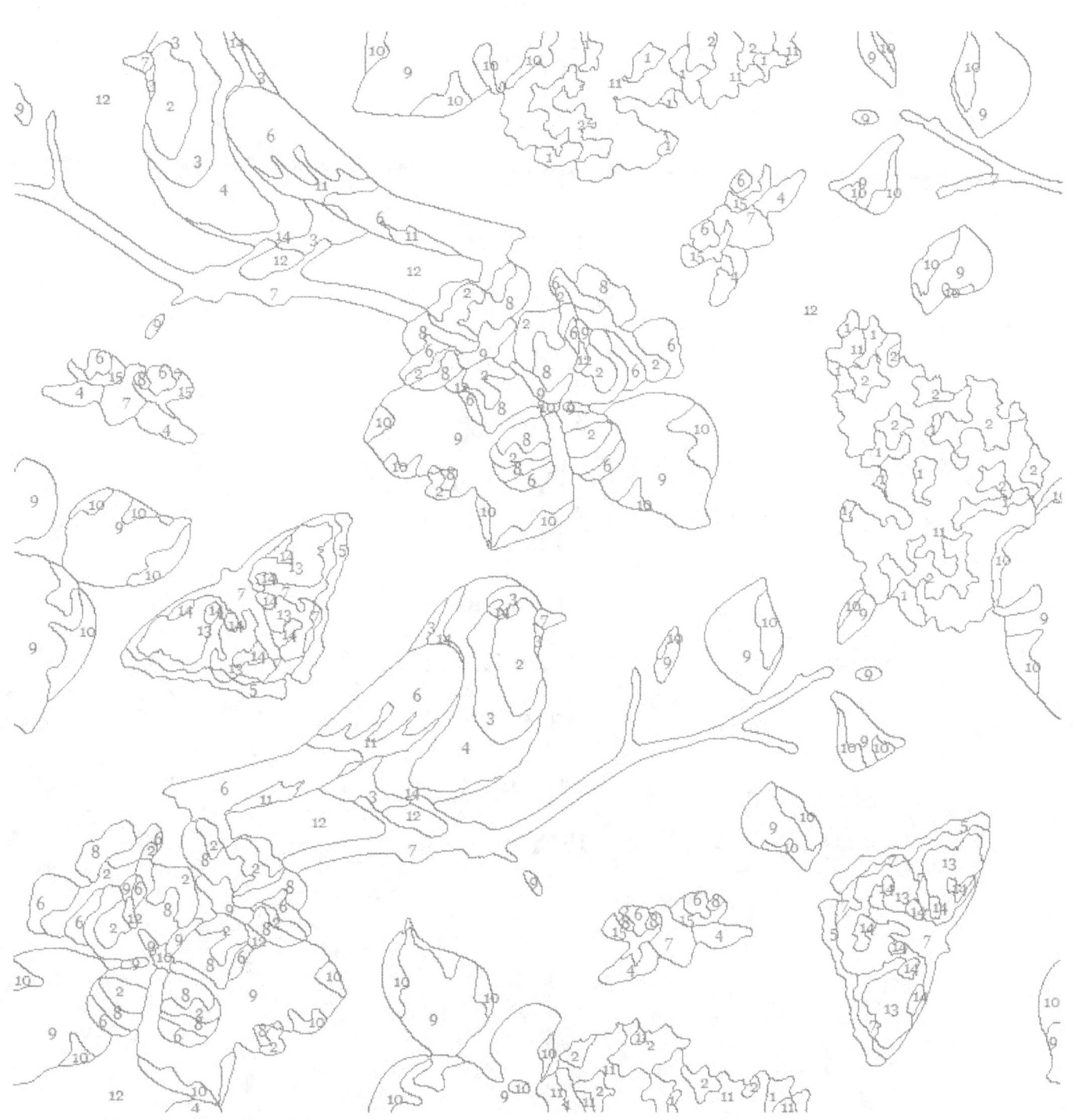

1. Red
2. Green
3. Blue
4. Pink
5. Purple
6. Light Blue
7. Light Green
8. Orange
9. Dark Red
10. Brown
11. Black
12. Dark Green
13. Gold
14. Violet
15. Yellow

1. Red
2. Green
3. Blue
4. Pink
5. Purple
6. Light Blue
7. Light Green
8. Orange
9. Dark Red
10. Brown
11. Black
12. Dark Green
13. Gold
14. Violet
15. Yellow

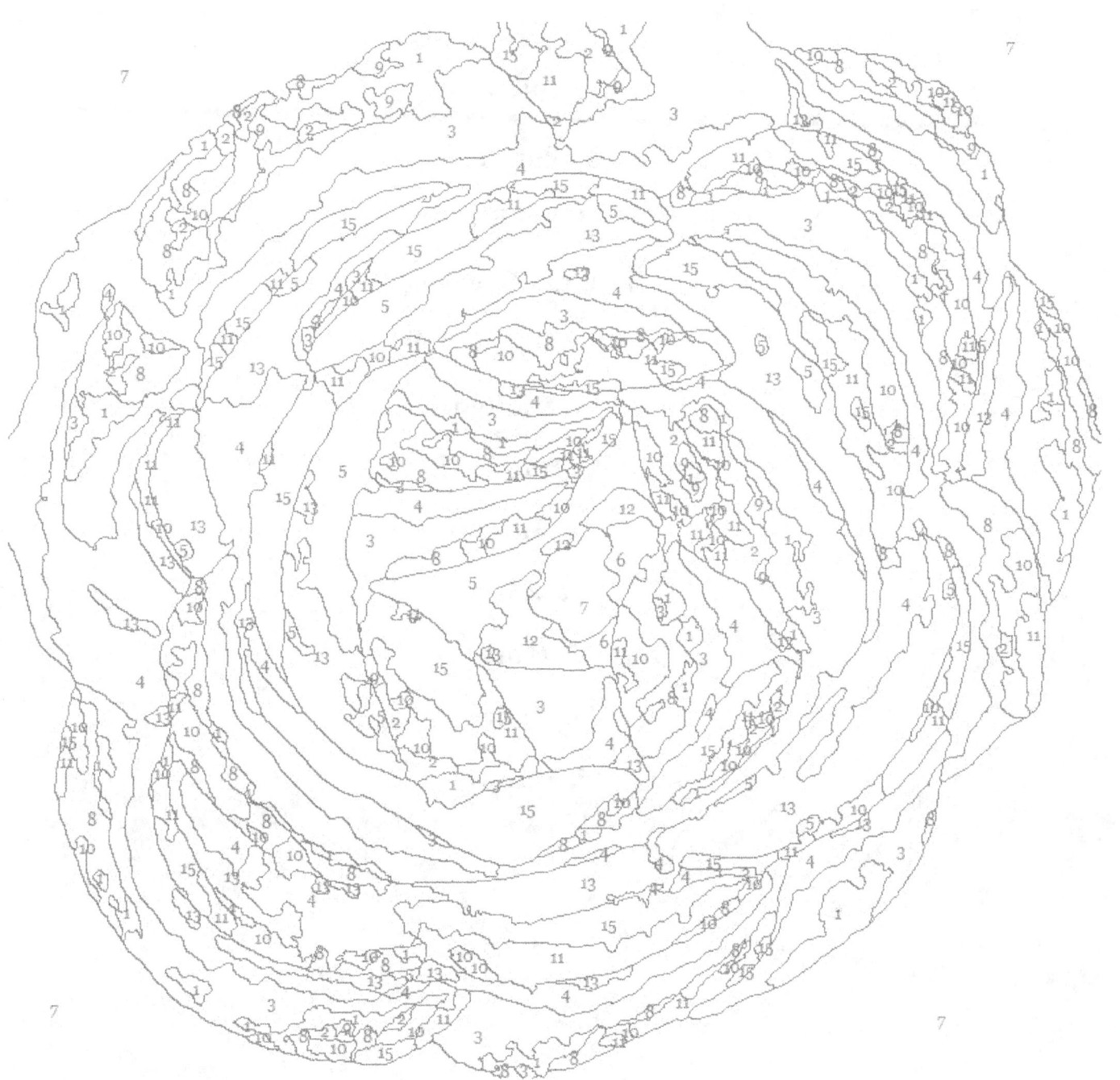

1. Red
2. Green
3. Blue
4. Pink
5. Purple
6. Light Blue
7. Light Green
8. Orange
9. Dark Red
10. Brown
11. Black
12. Dark Green
13. Gold
14. Violet
15. Yellow

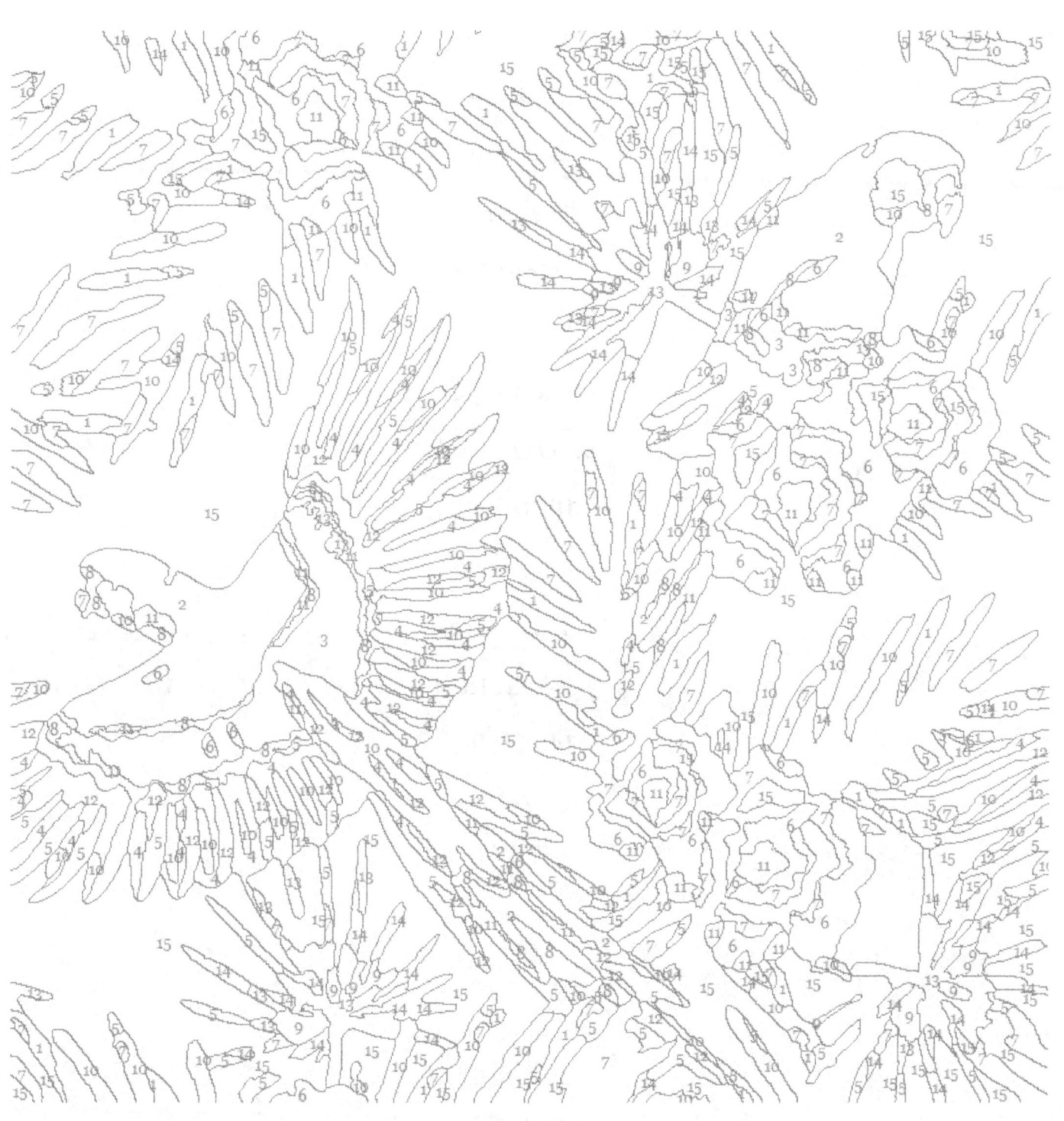

1. Red
2. Green
3. Blue
4. Pink
5. Purple
6. Light Blue
7. Light Green
8. Orange
9. Dark Red
10. Brown
11. Black
12. Dark Green
13. Gold
14. Violet
15. Yellow

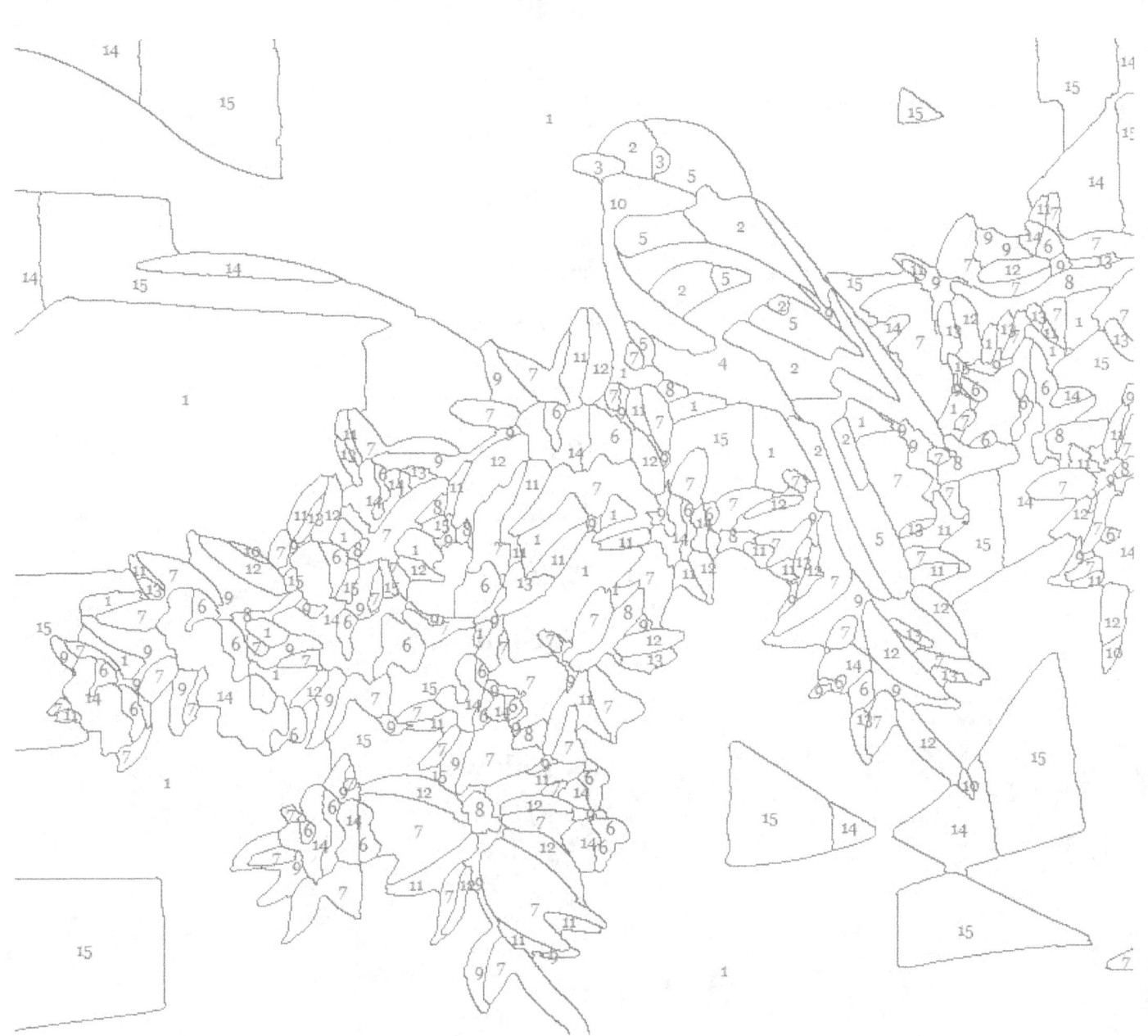

1. Red
2. Green
3. Blue
4. Pink
5. Purple
6. Light Blue
7. Light Green
8. Orange
9. Dark Red
10. Brown
11. Black
12. Dark Green
13. Gold
14. Violet
15. Yellow

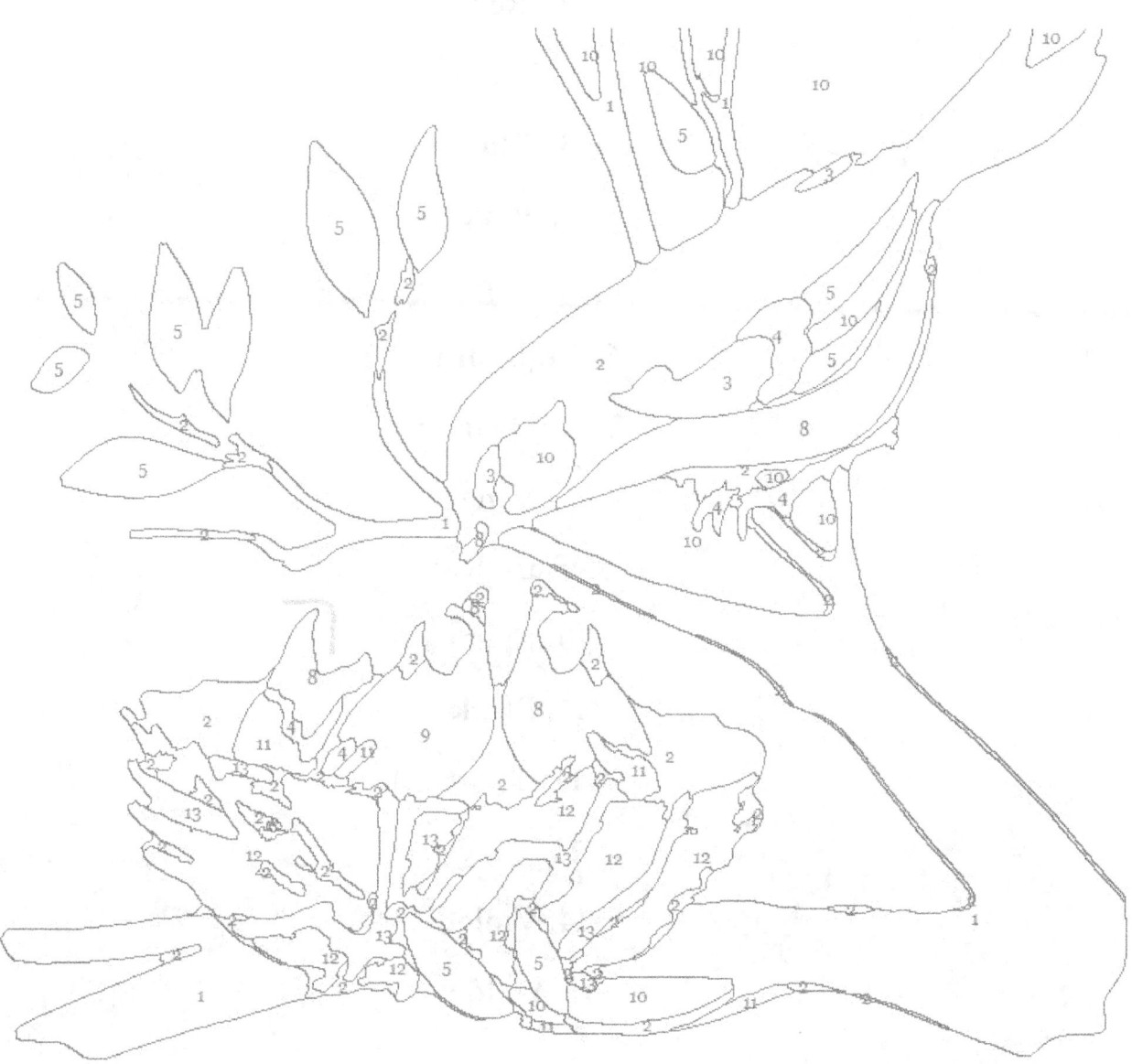

1. Red
2. Green
3. Blue
4. Pink
5. Purple
6. Light Blue
7. Light Green
8. Orange
9. Dark Red
10. Brown
11. Black
12. Dark Green
13. Gold
14. Violet
15. Yellow

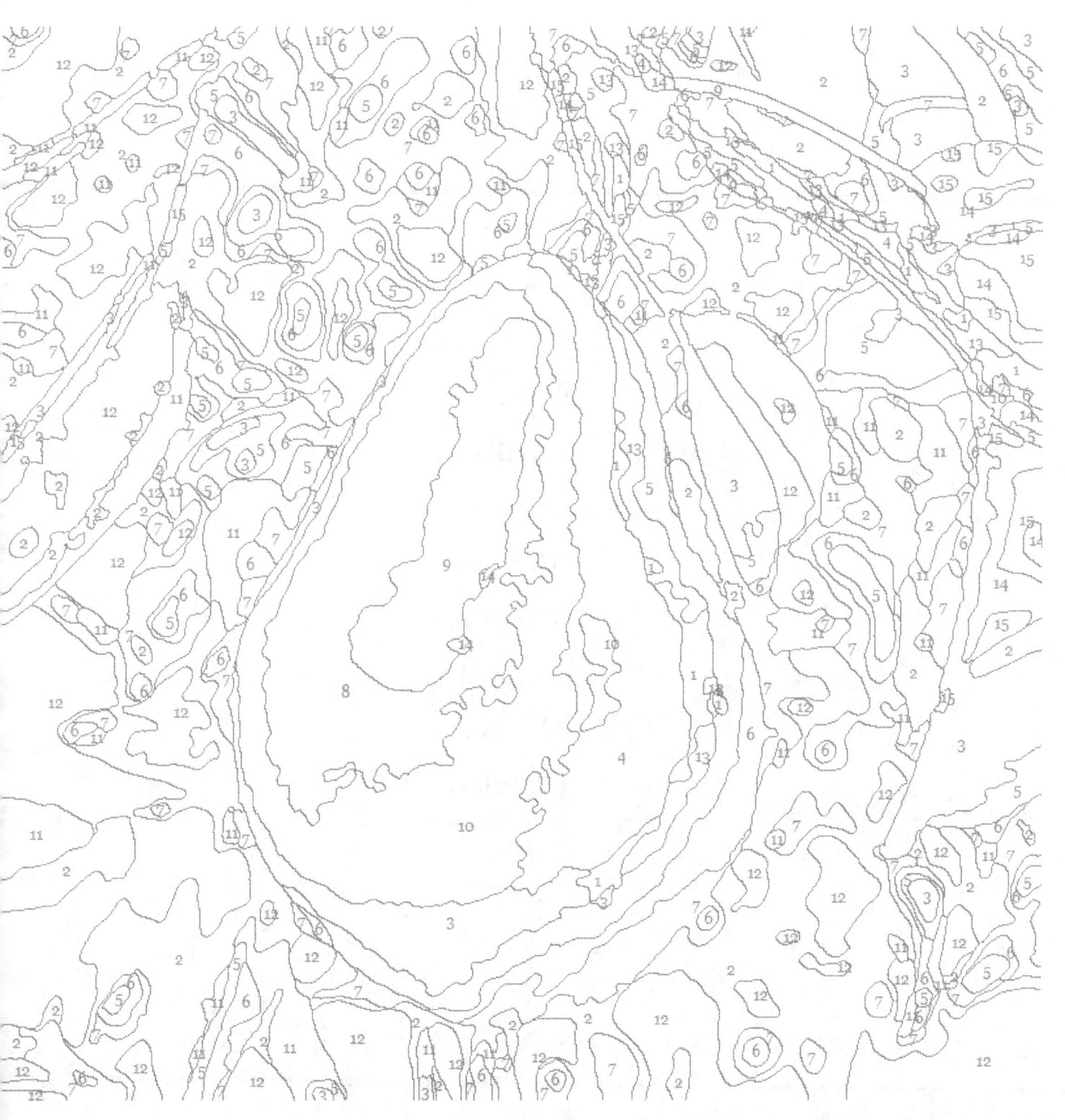

1. Red
2. Green
3. Blue
4. Pink
5. Purple
6. Light Blue
7. Light Green
8. Orange
9. Dark Red
10. Brown
11. Black
12. Dark Green
13. Gold
14. Violet
15. Yellow

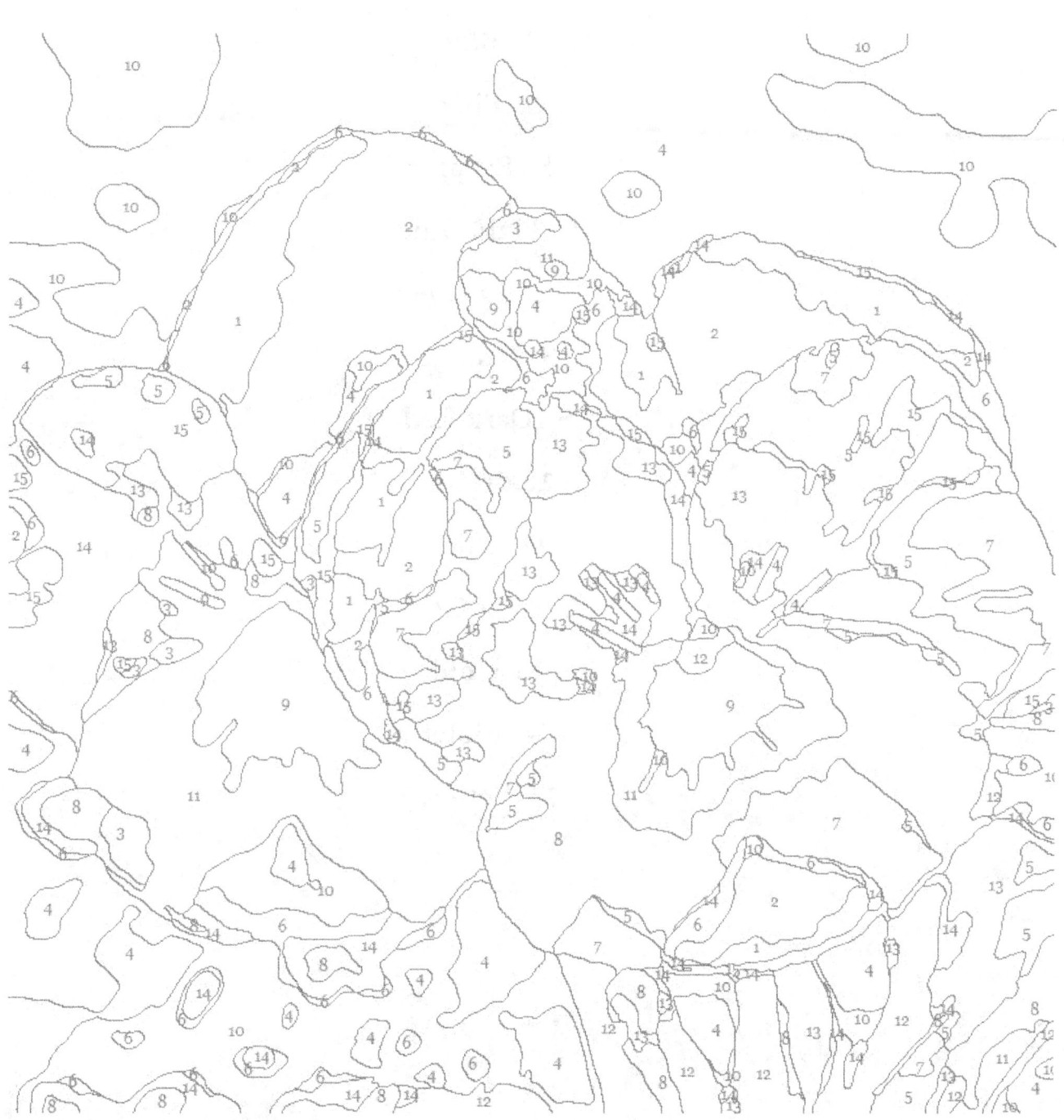

1. Red
2. Green
3. Blue
4. Pink
5. Purple
6. Light Blue
7. Light Green
8. Orange
9. Dark Red
10. Brown
11. Black
12. Dark Green
13. Gold
14. Violet
15. Yellow

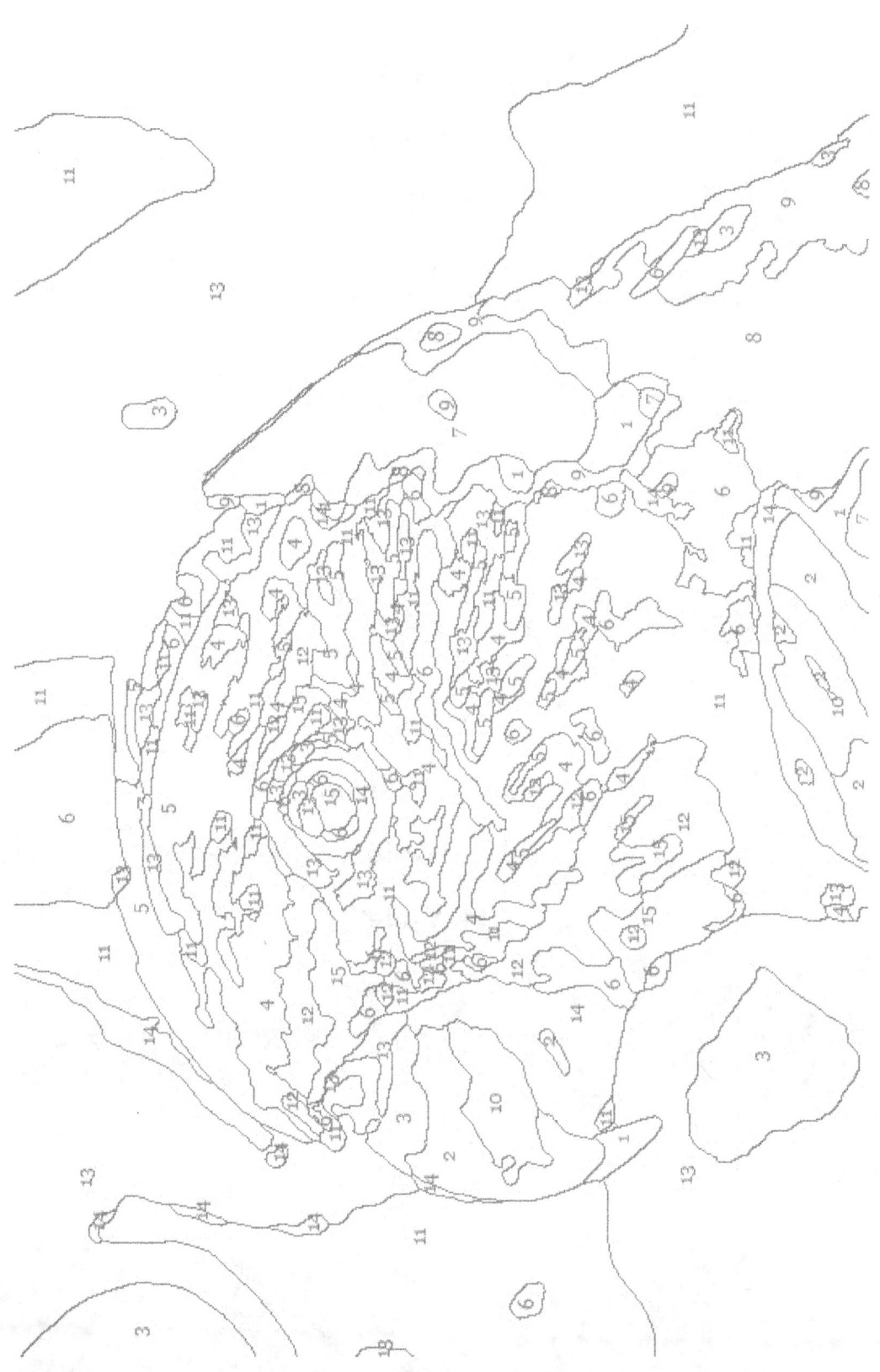

1. Red
2. Green
3. Blue
4. Pink
5. Purple
6. Light Blue
7. Light Green
8. Orange
9. Dark Red
10. Brown
11. Black
12. Dark Green
13. Gold
14. Violet
15. Yellow

www.ingramcontent.com/pod-product-compliance
Lightning Source LLC
Chambersburg PA
CBHW081014170526
45158CB00010B/3034